Adult Coloring Book

Florals and Animals
Mandalas and Doodle Designs
for Relaxation Meditation Blessing

I0391302

Vol.1

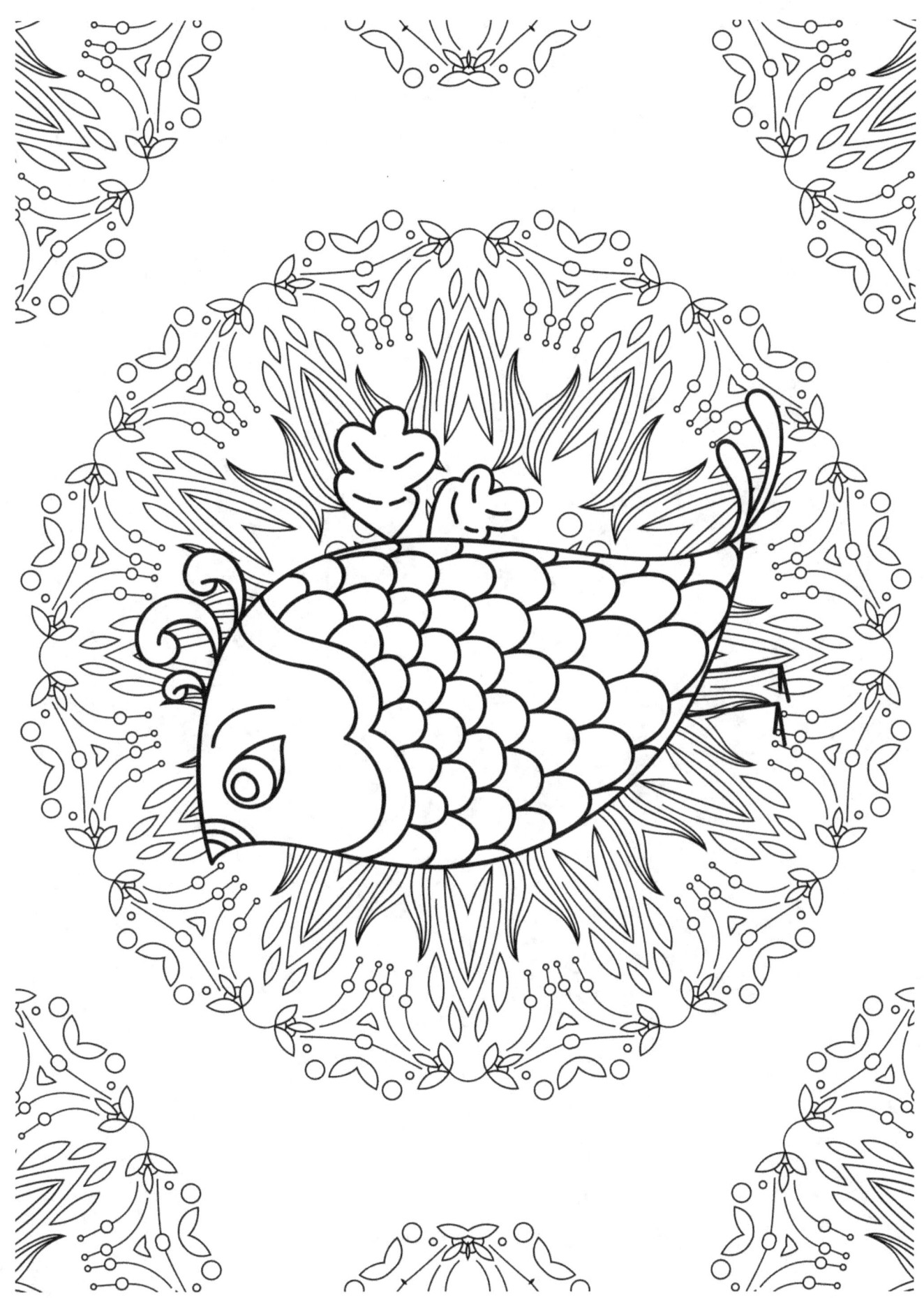

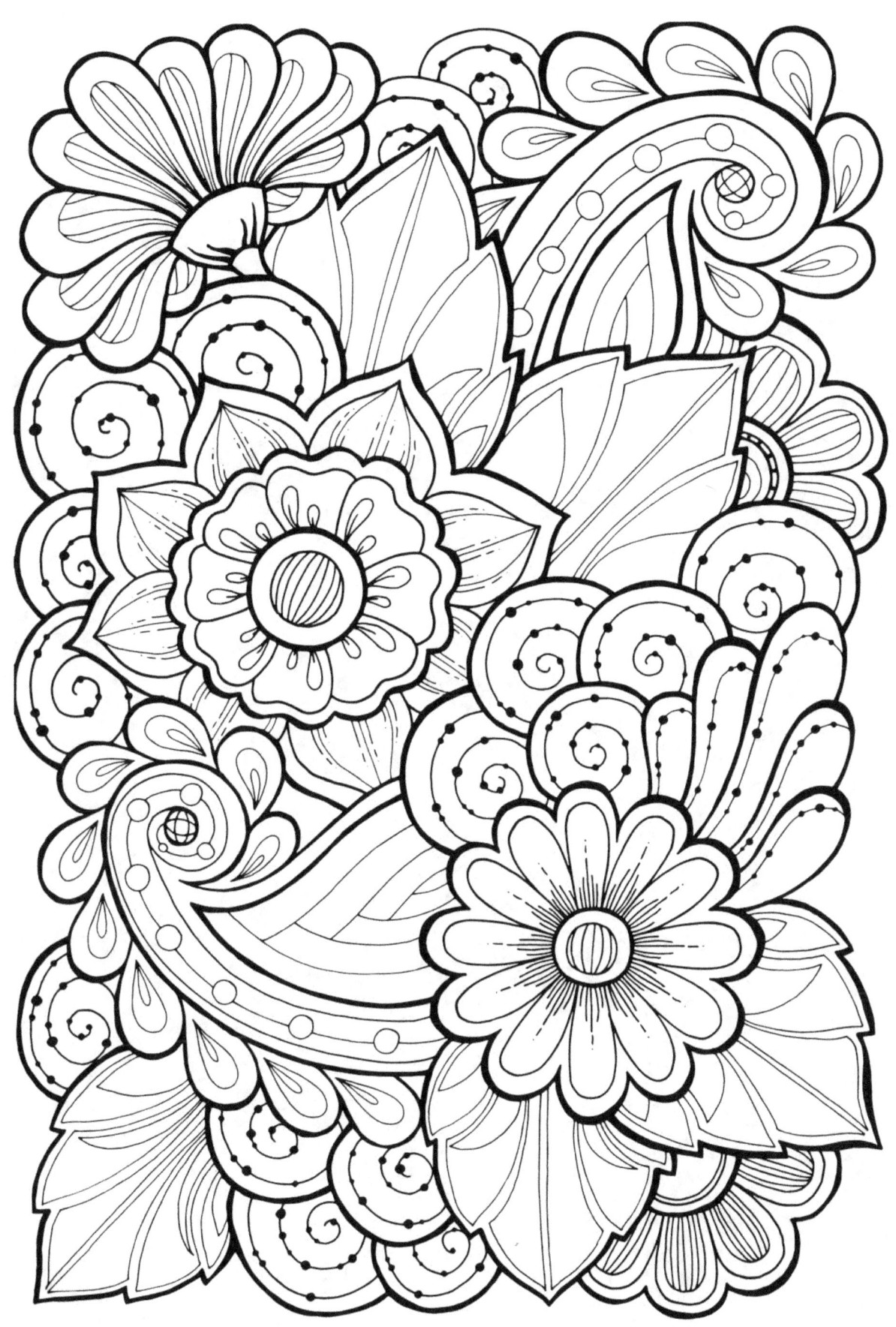

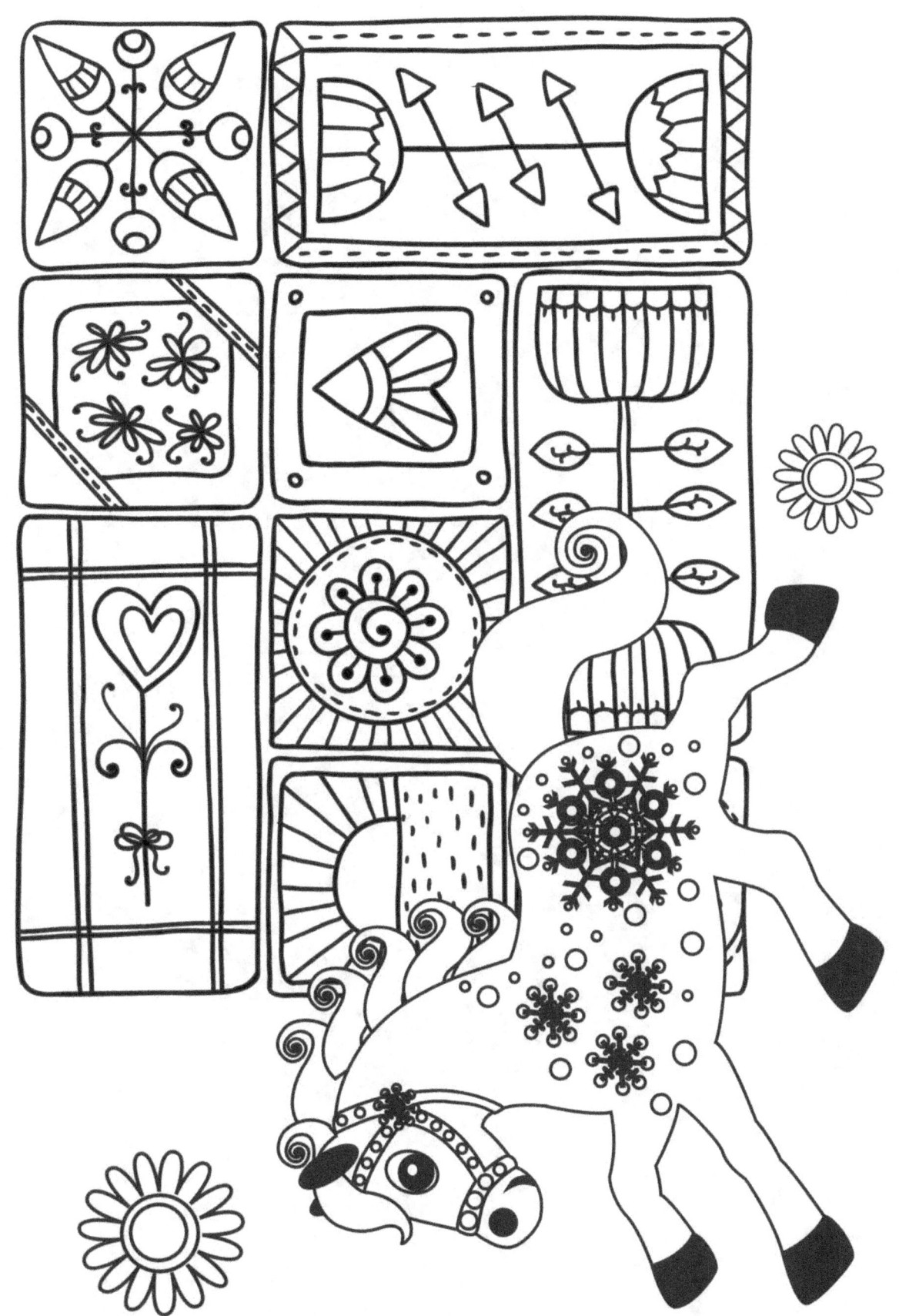

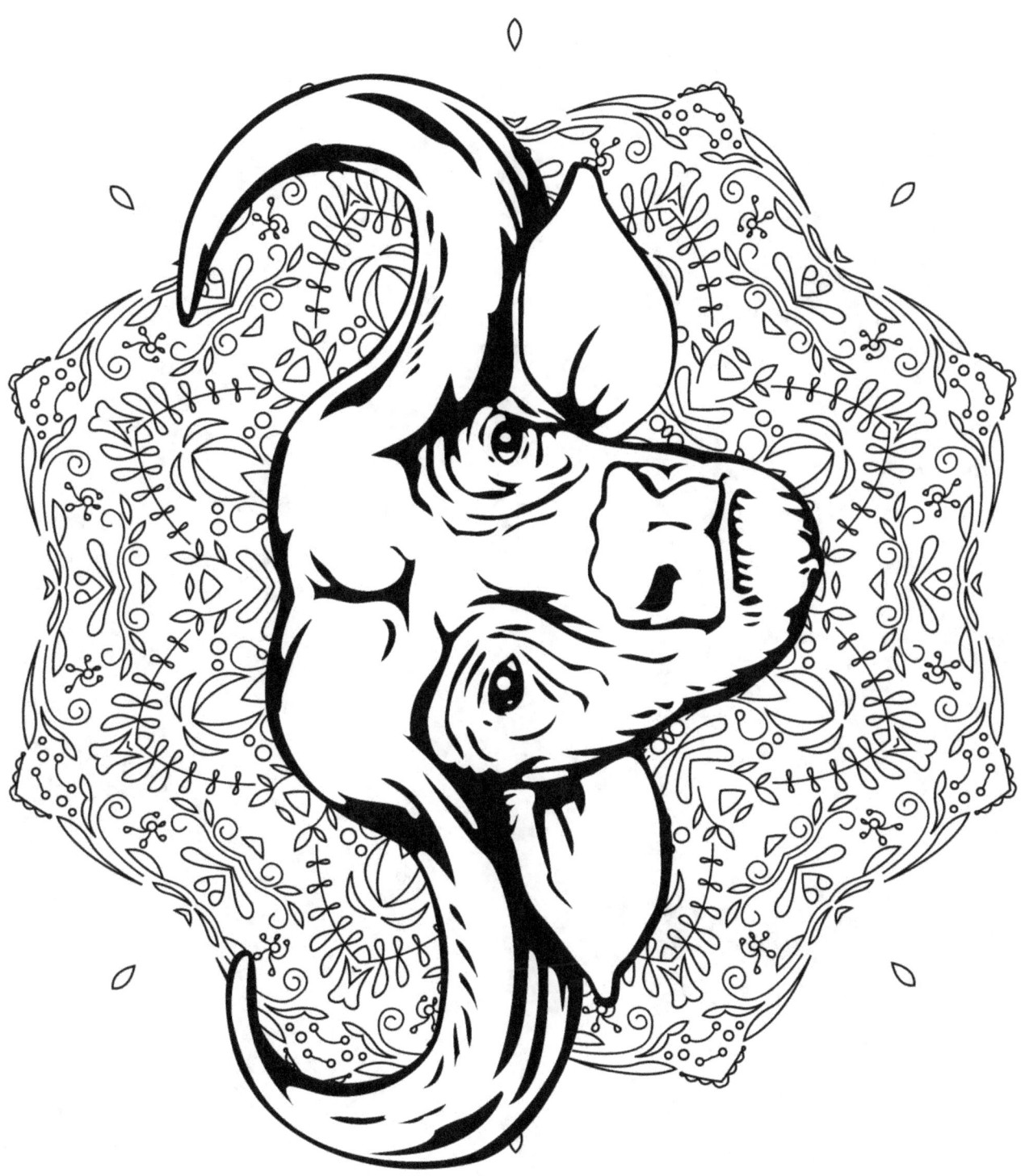

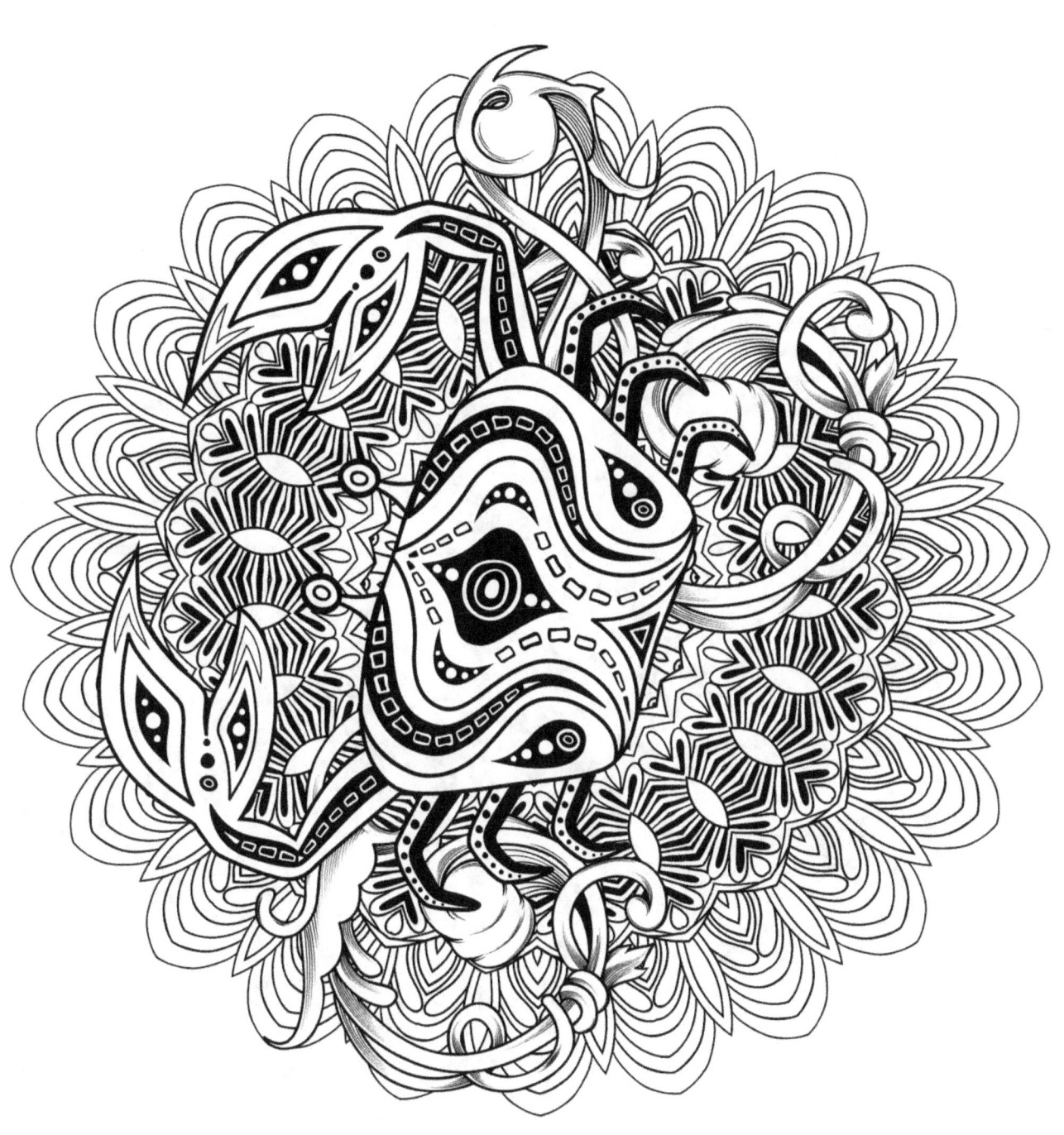

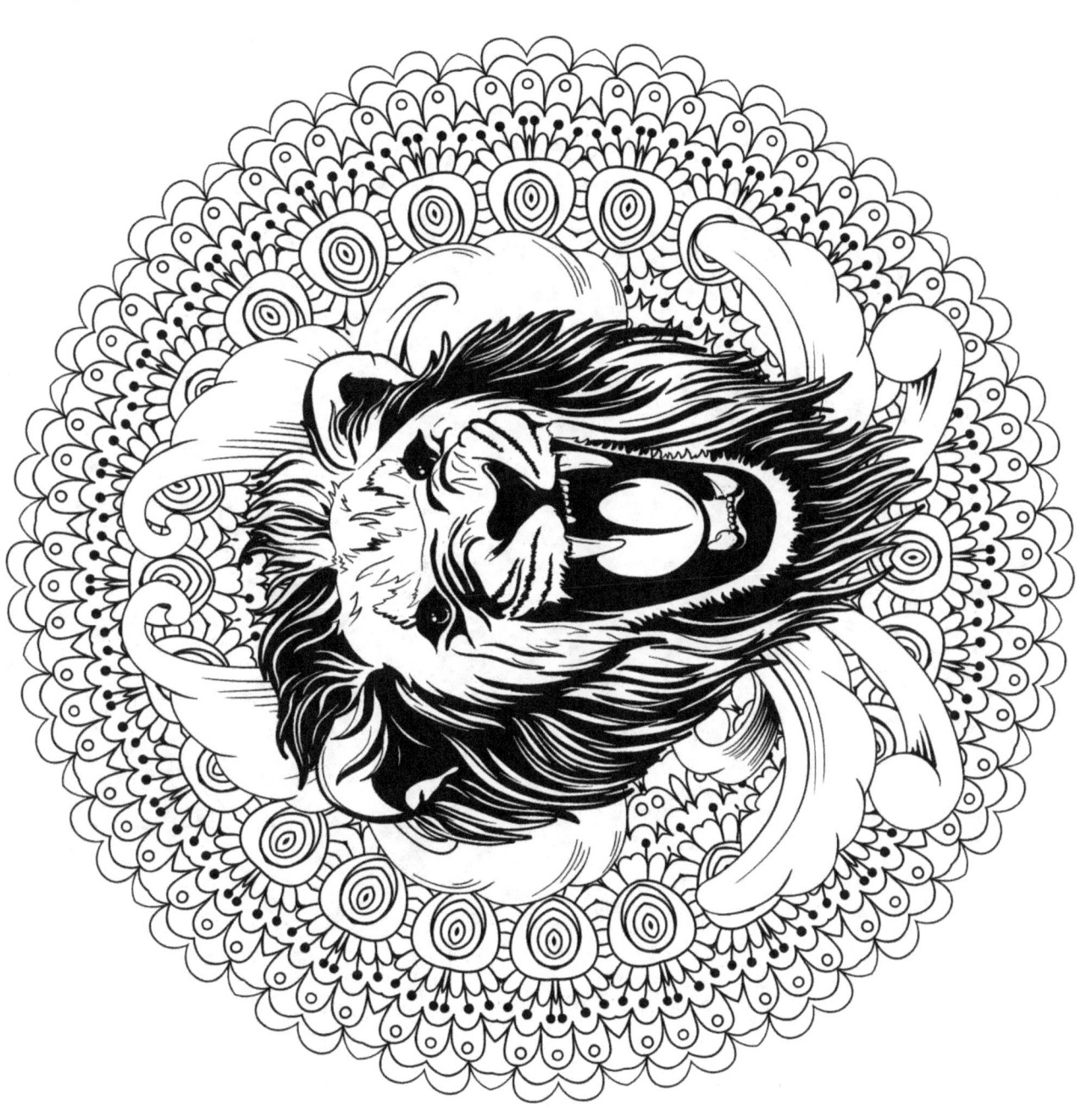

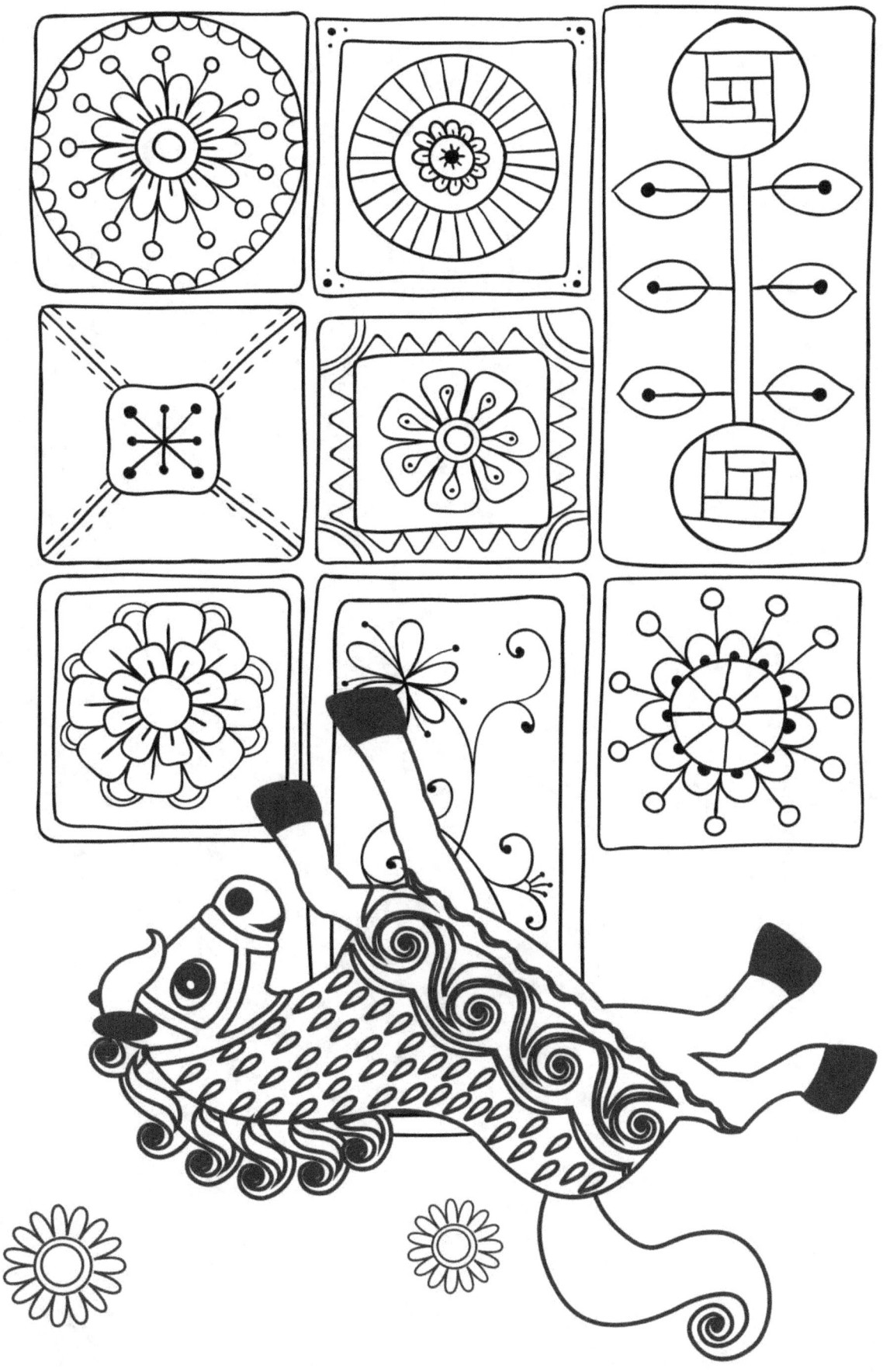

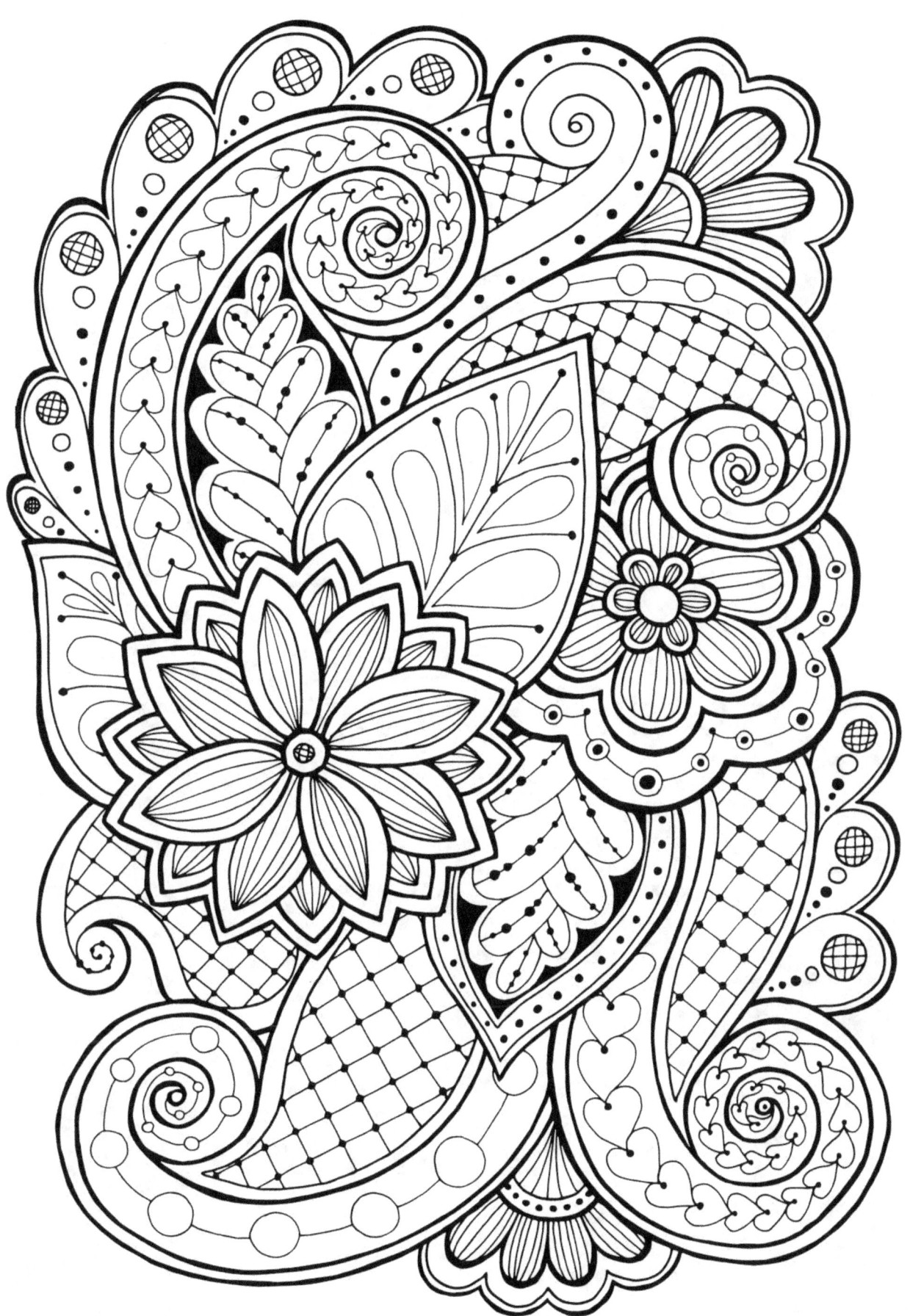

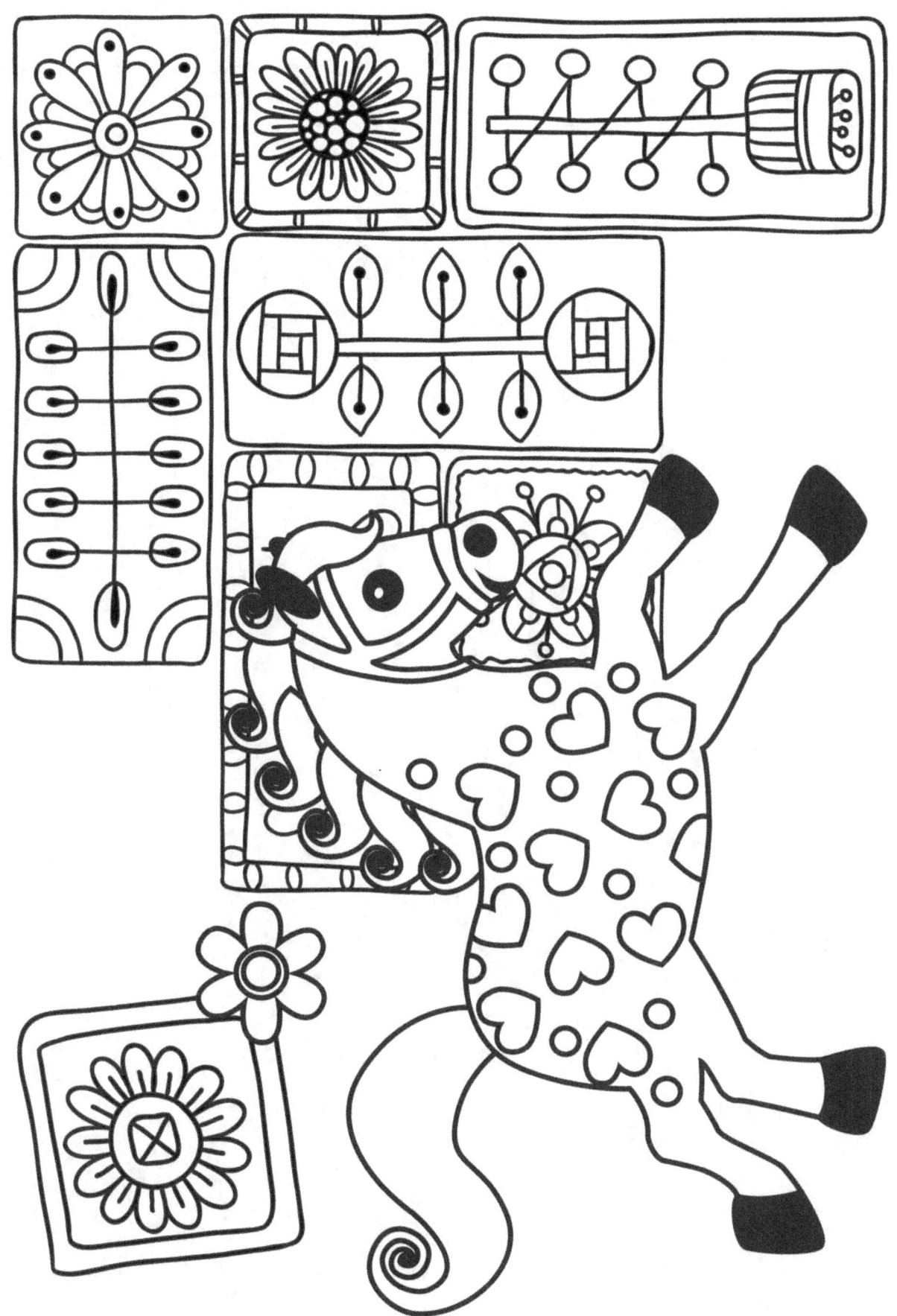

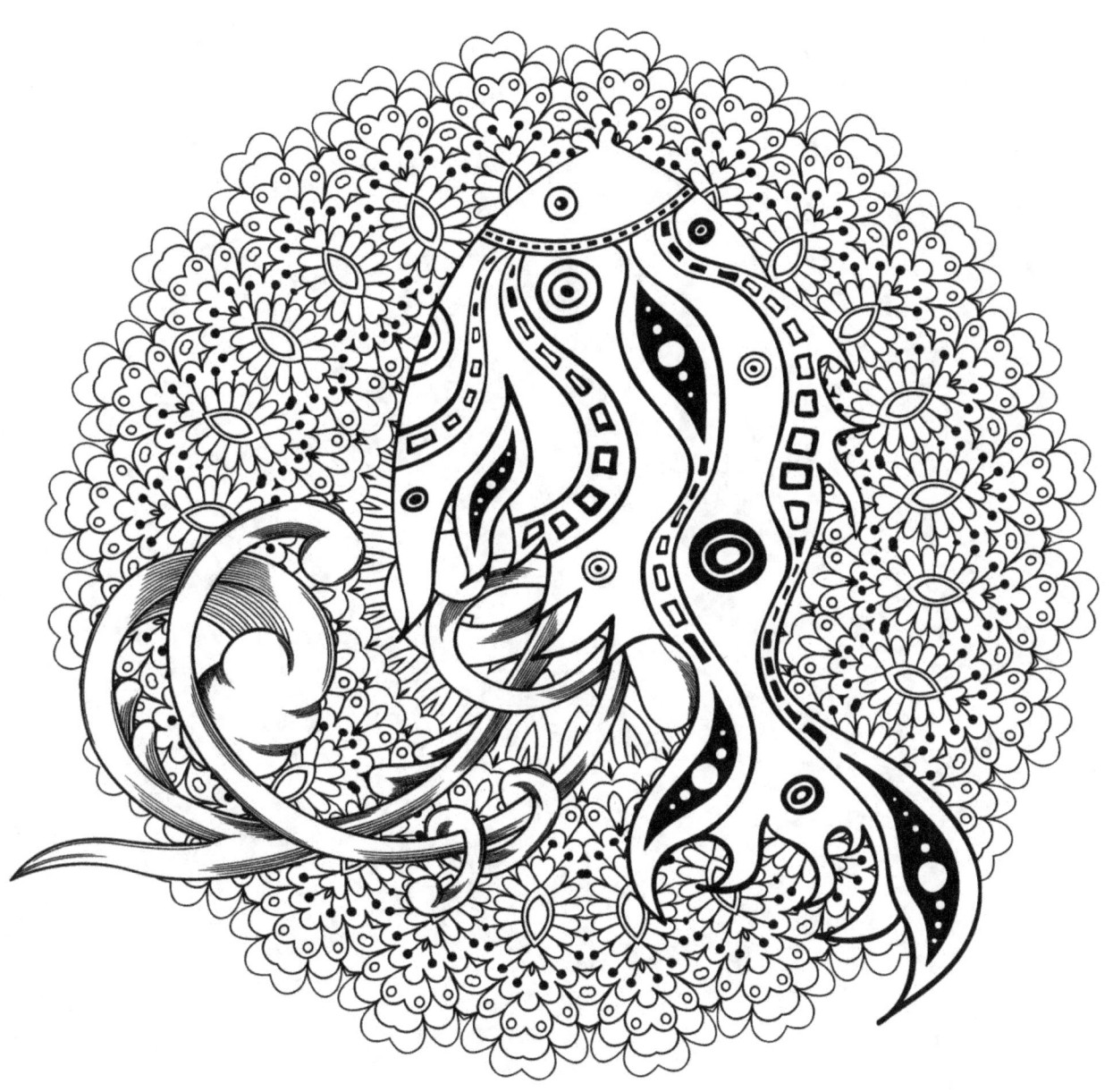

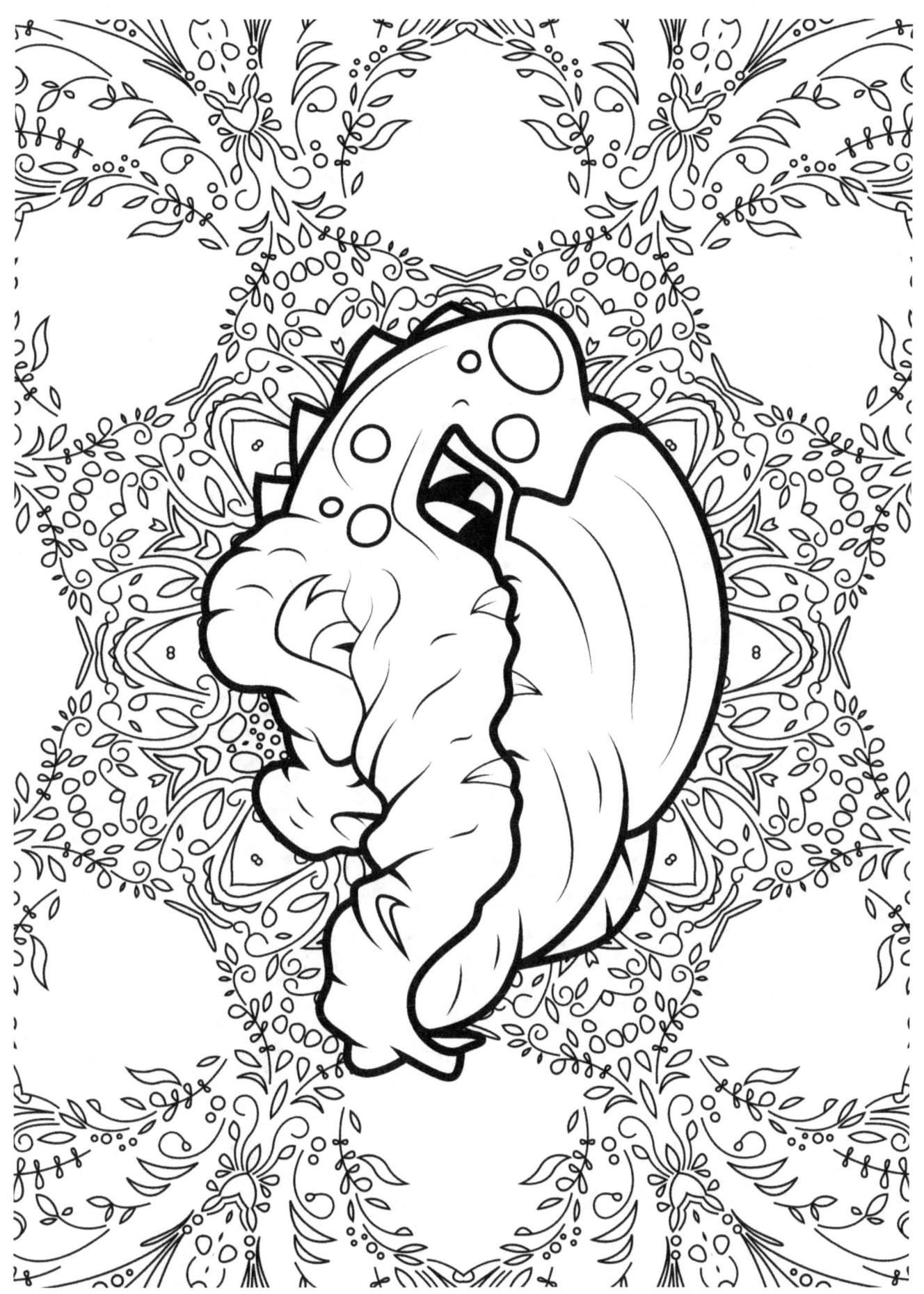

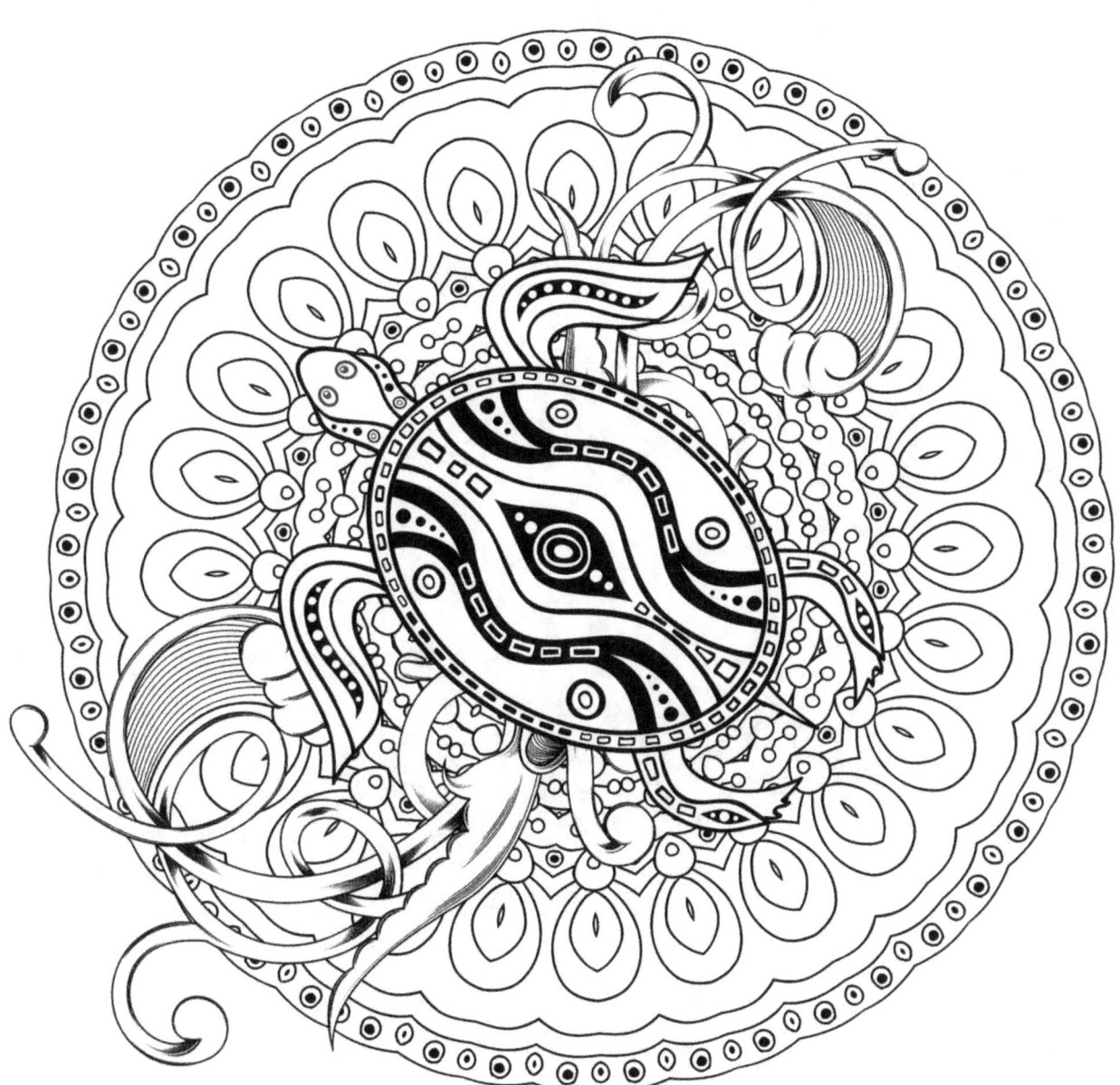

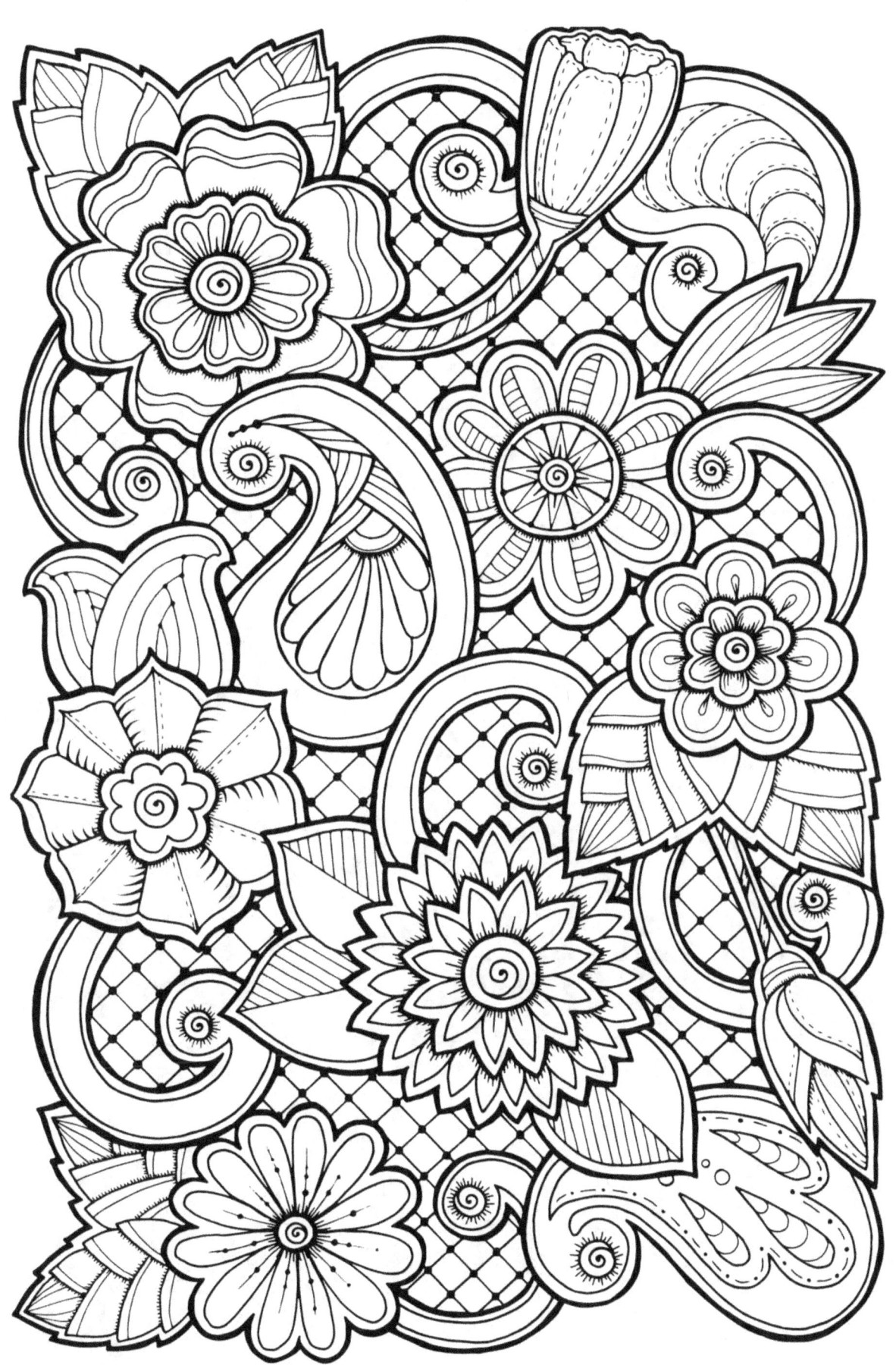

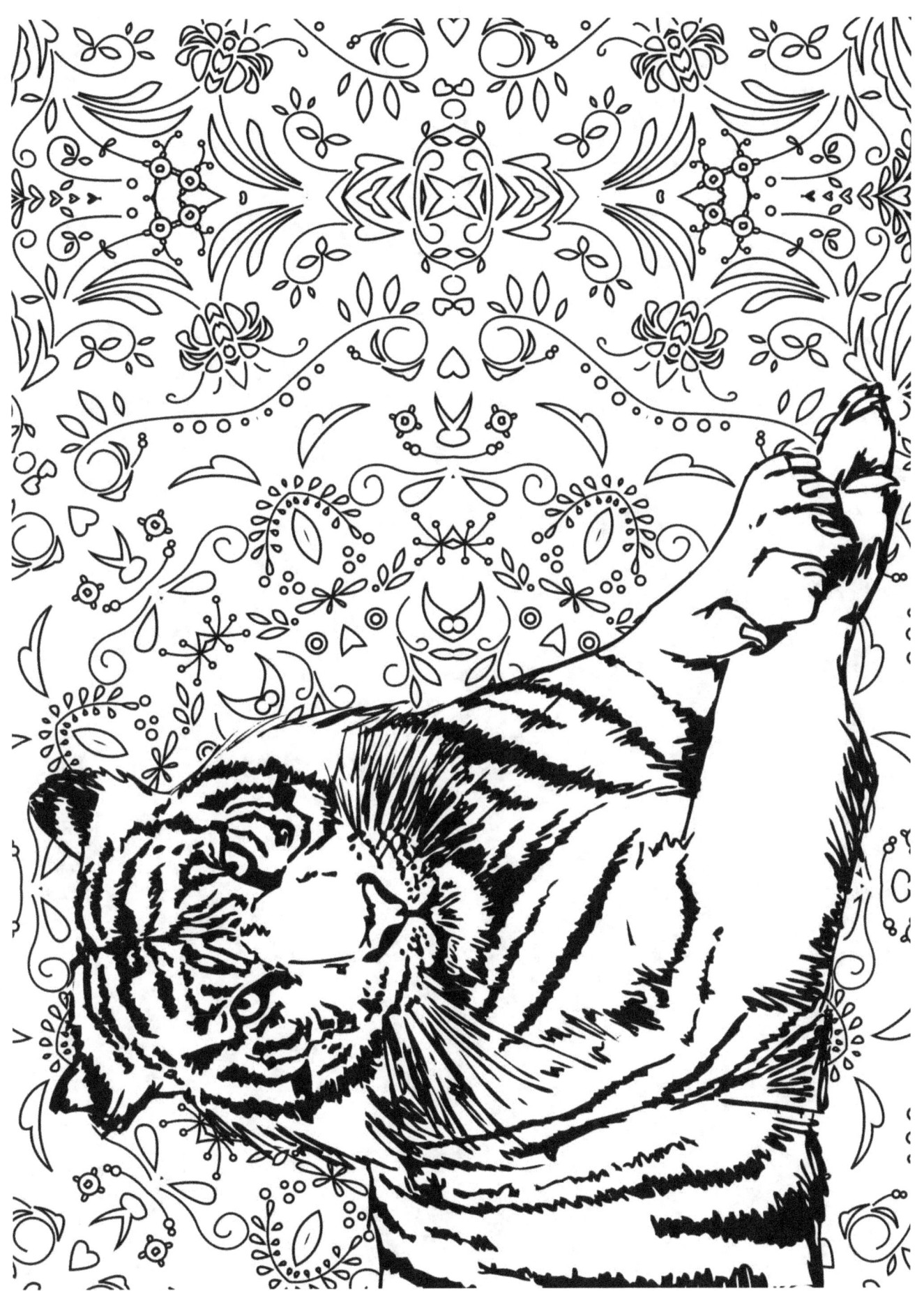

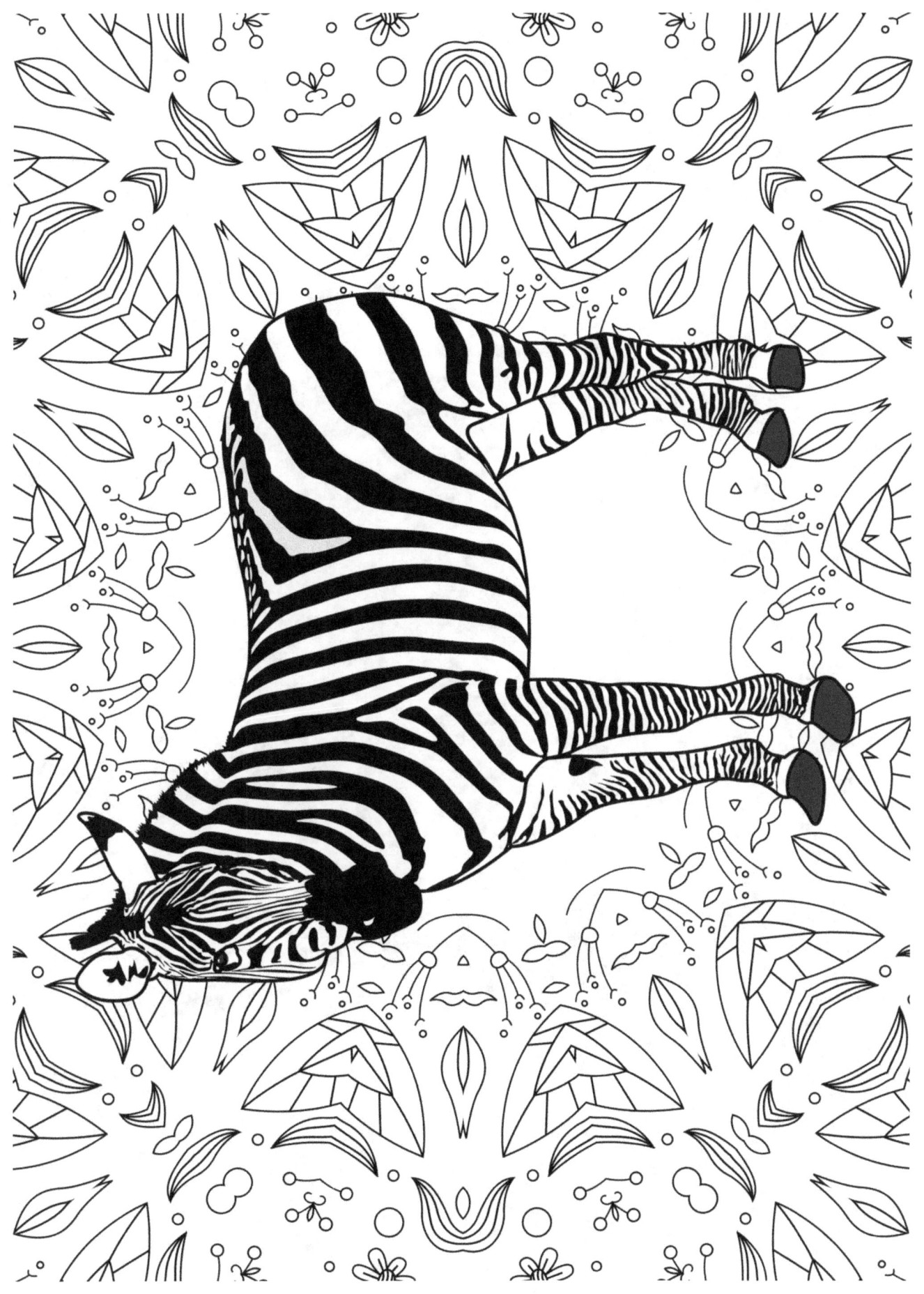

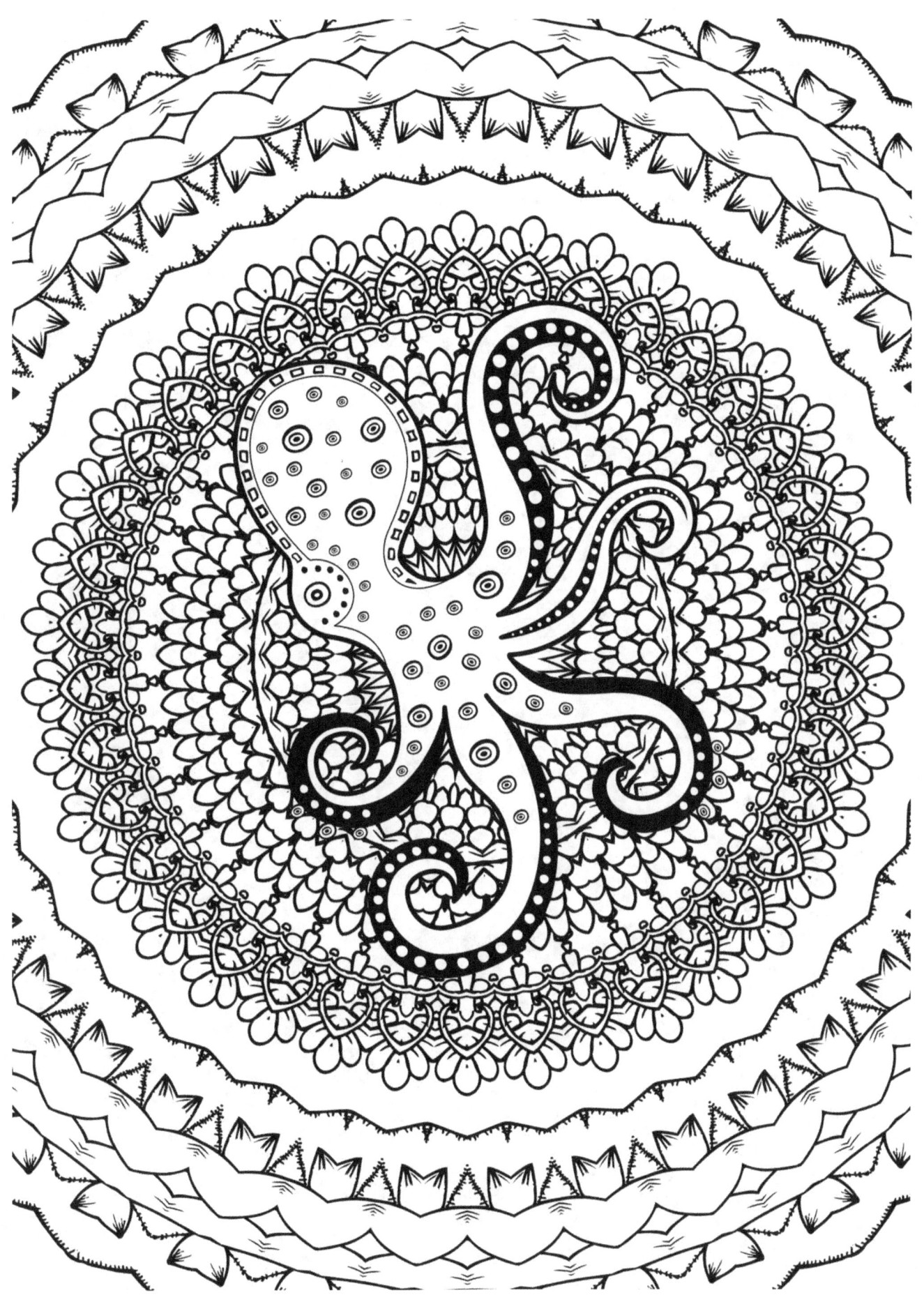

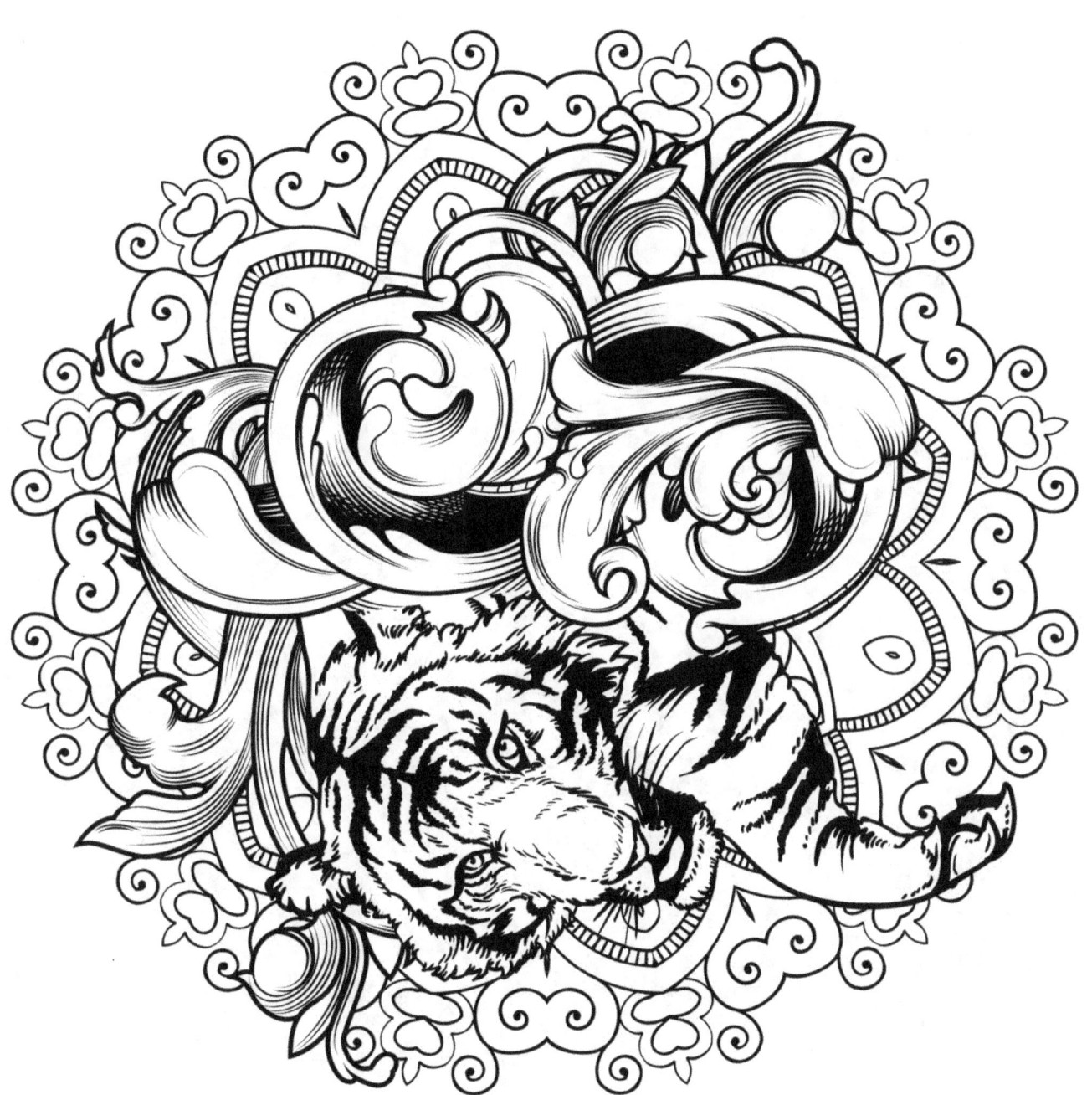

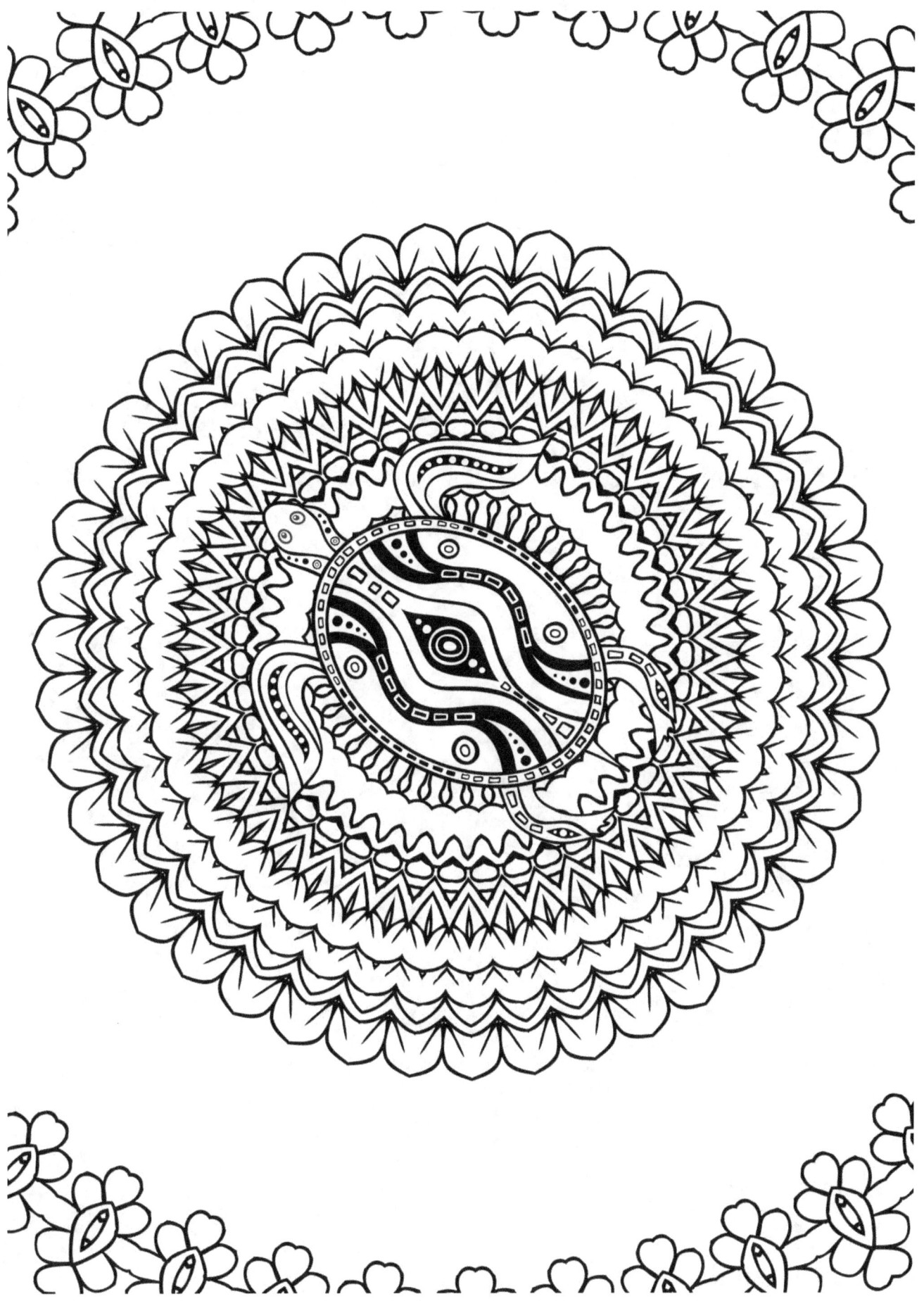

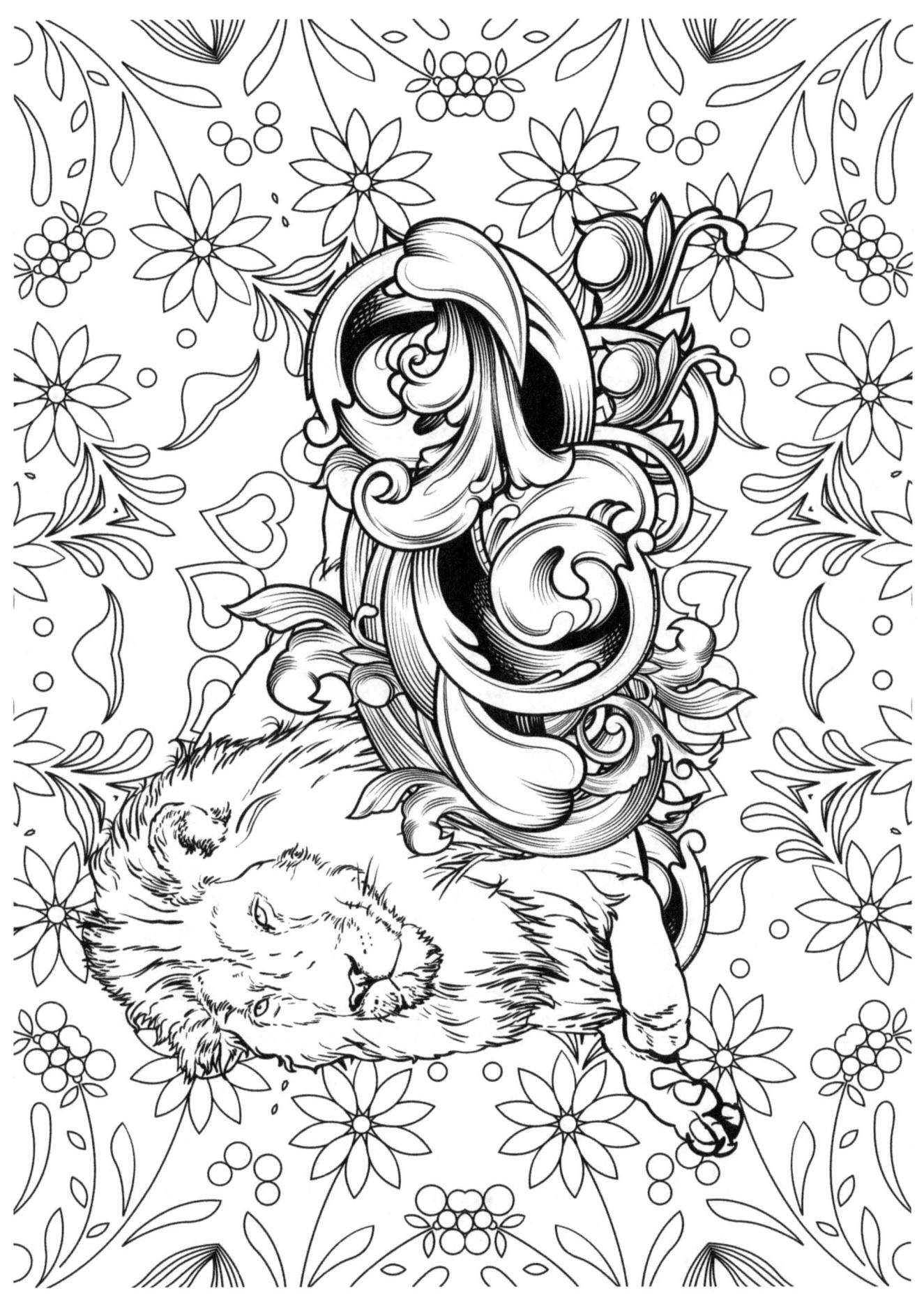

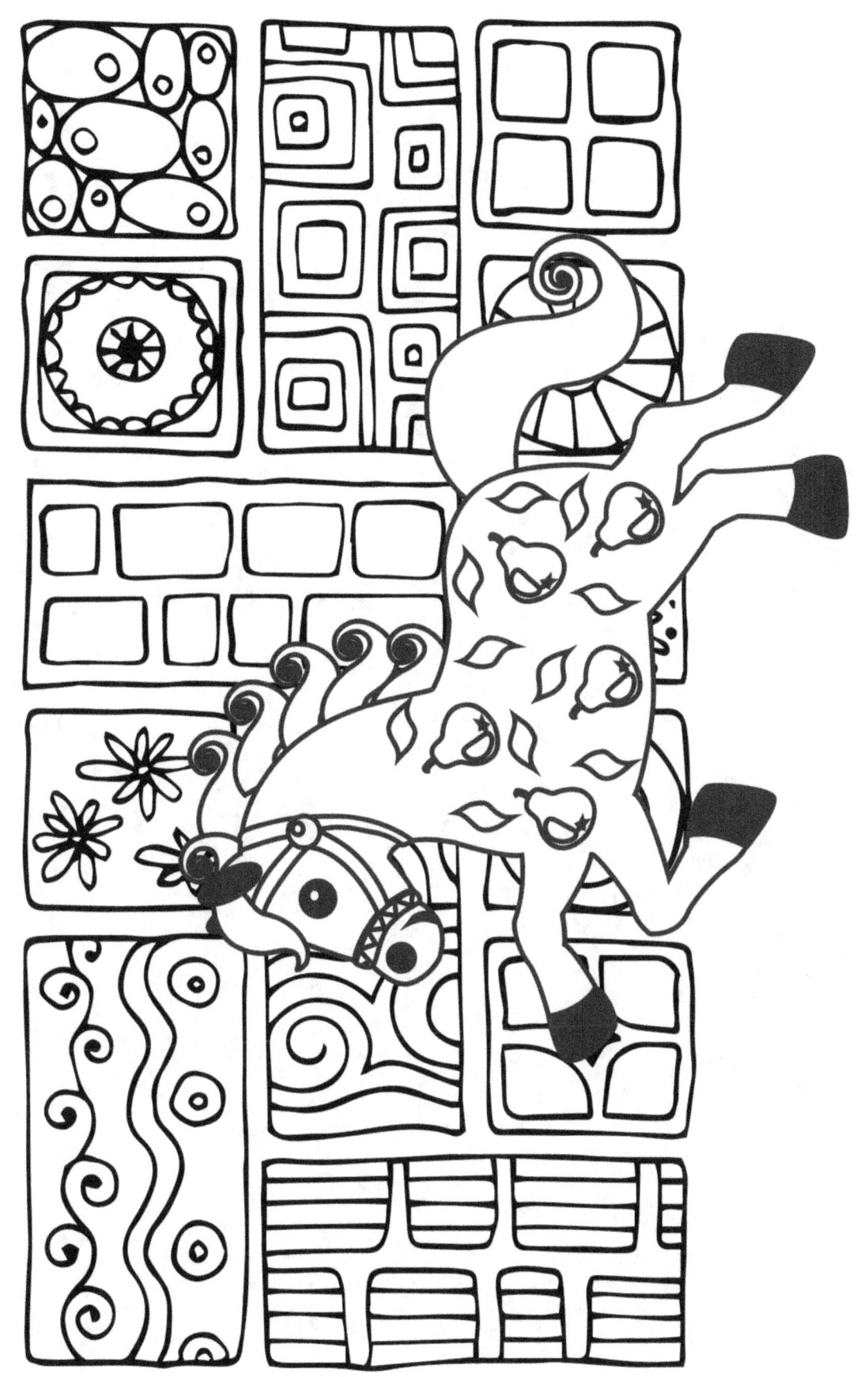

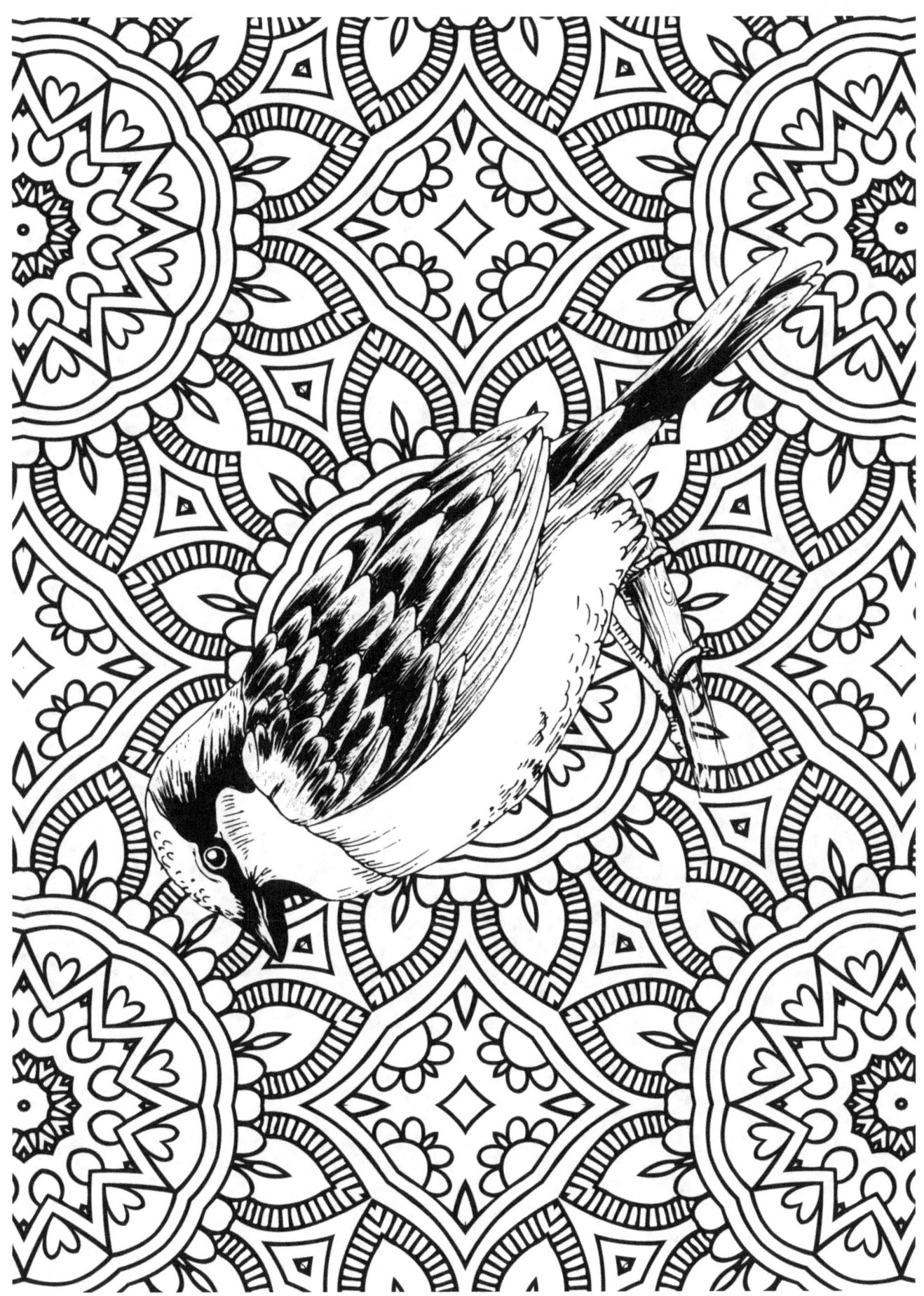

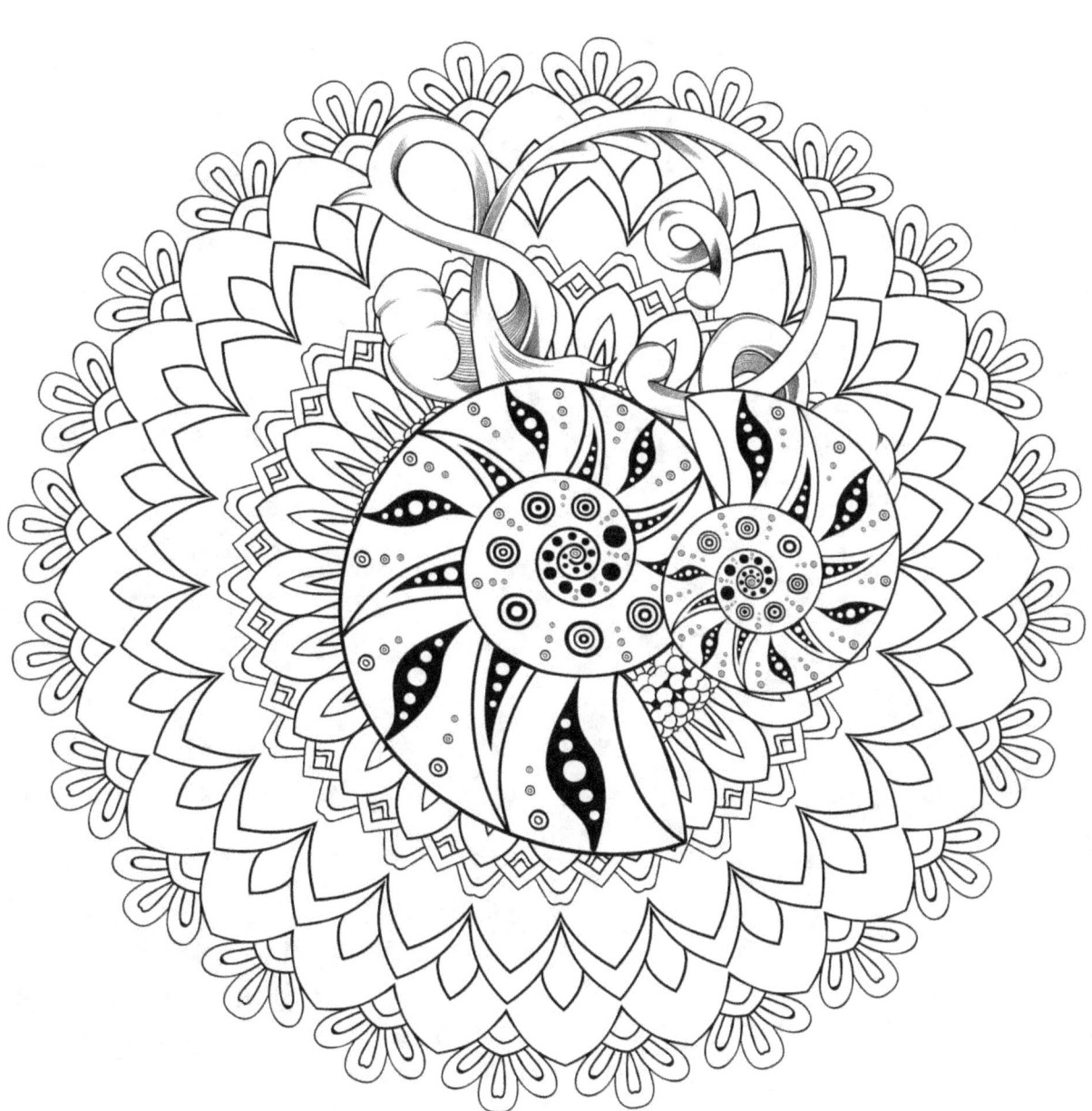

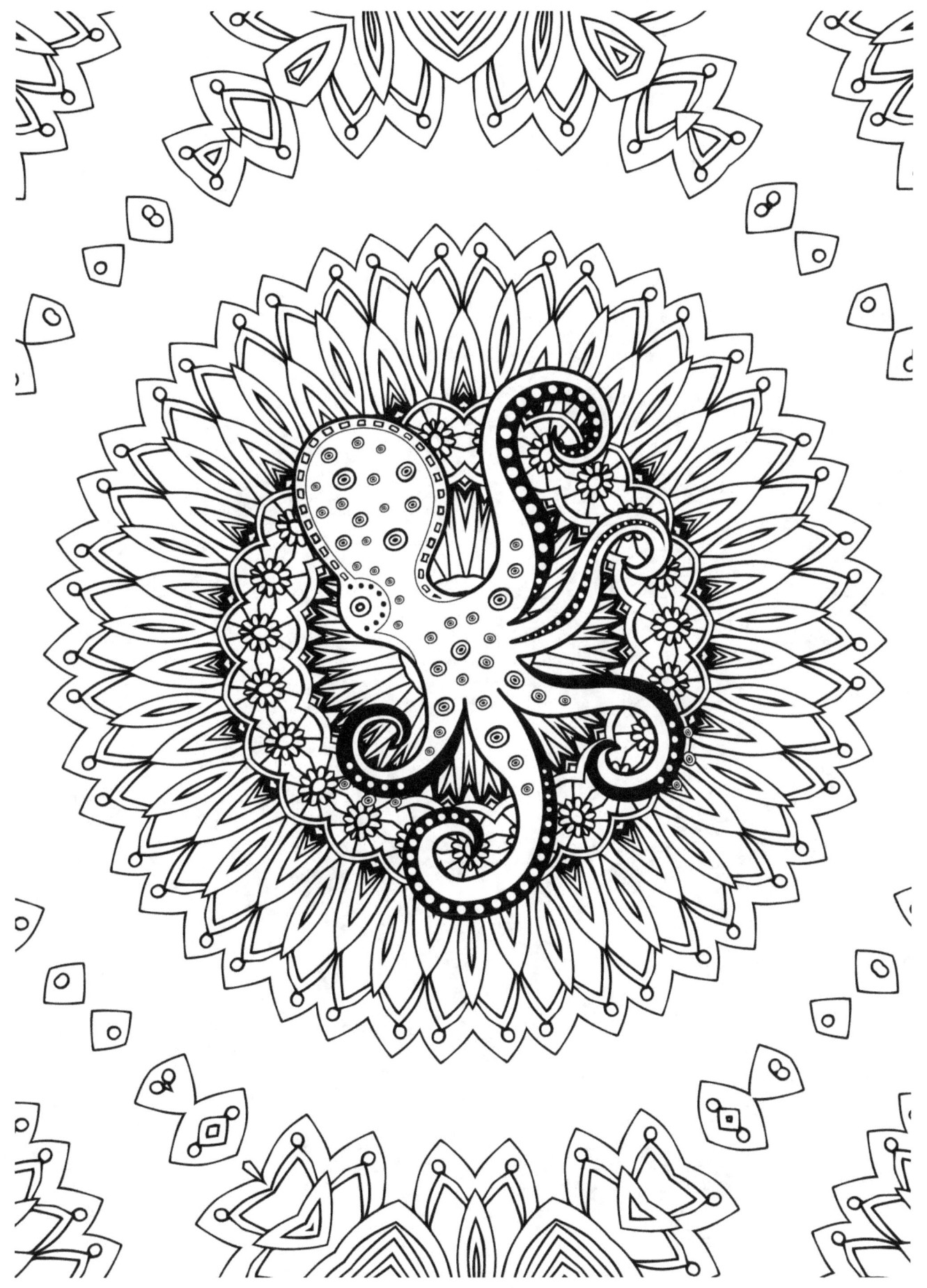

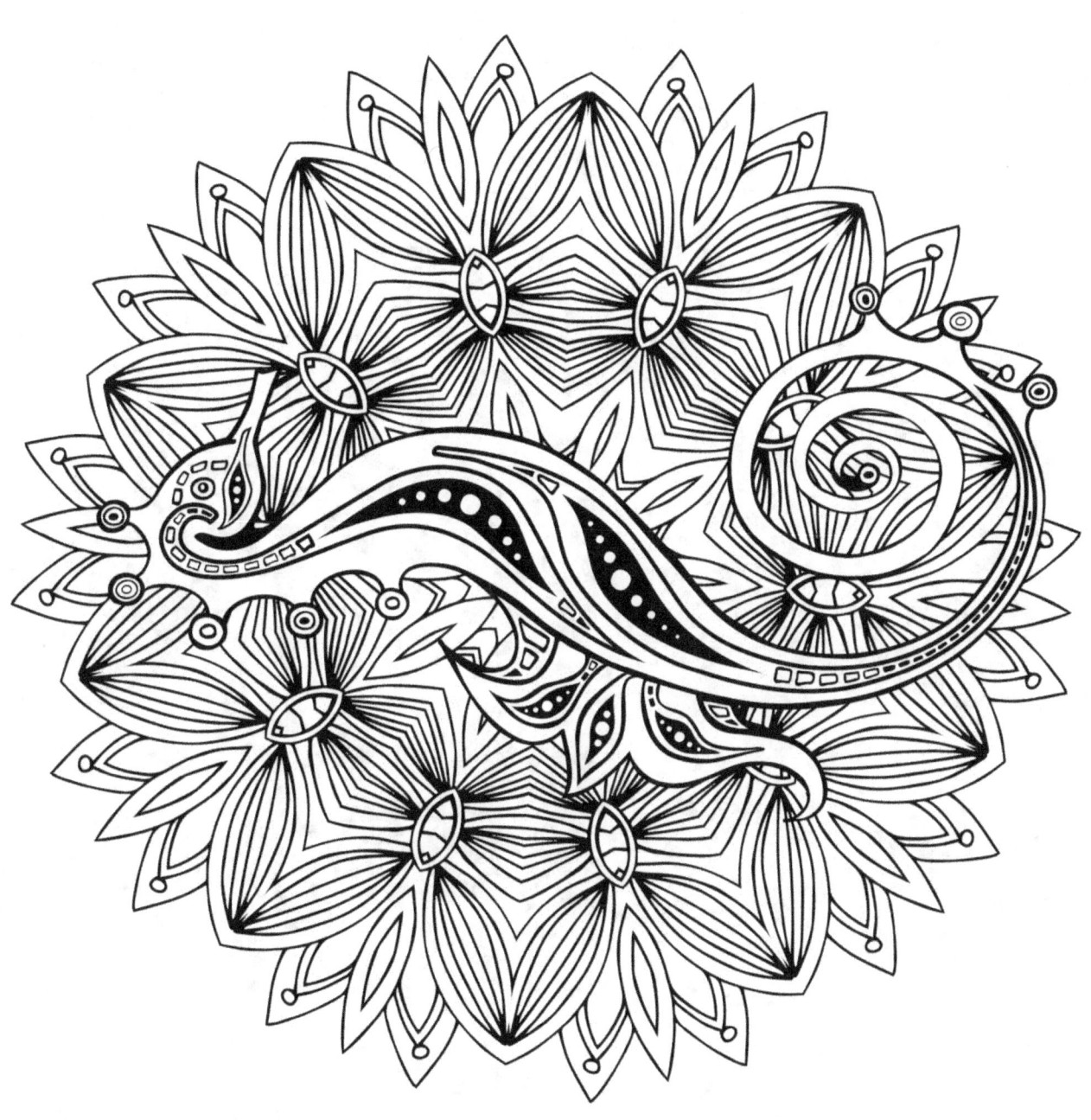

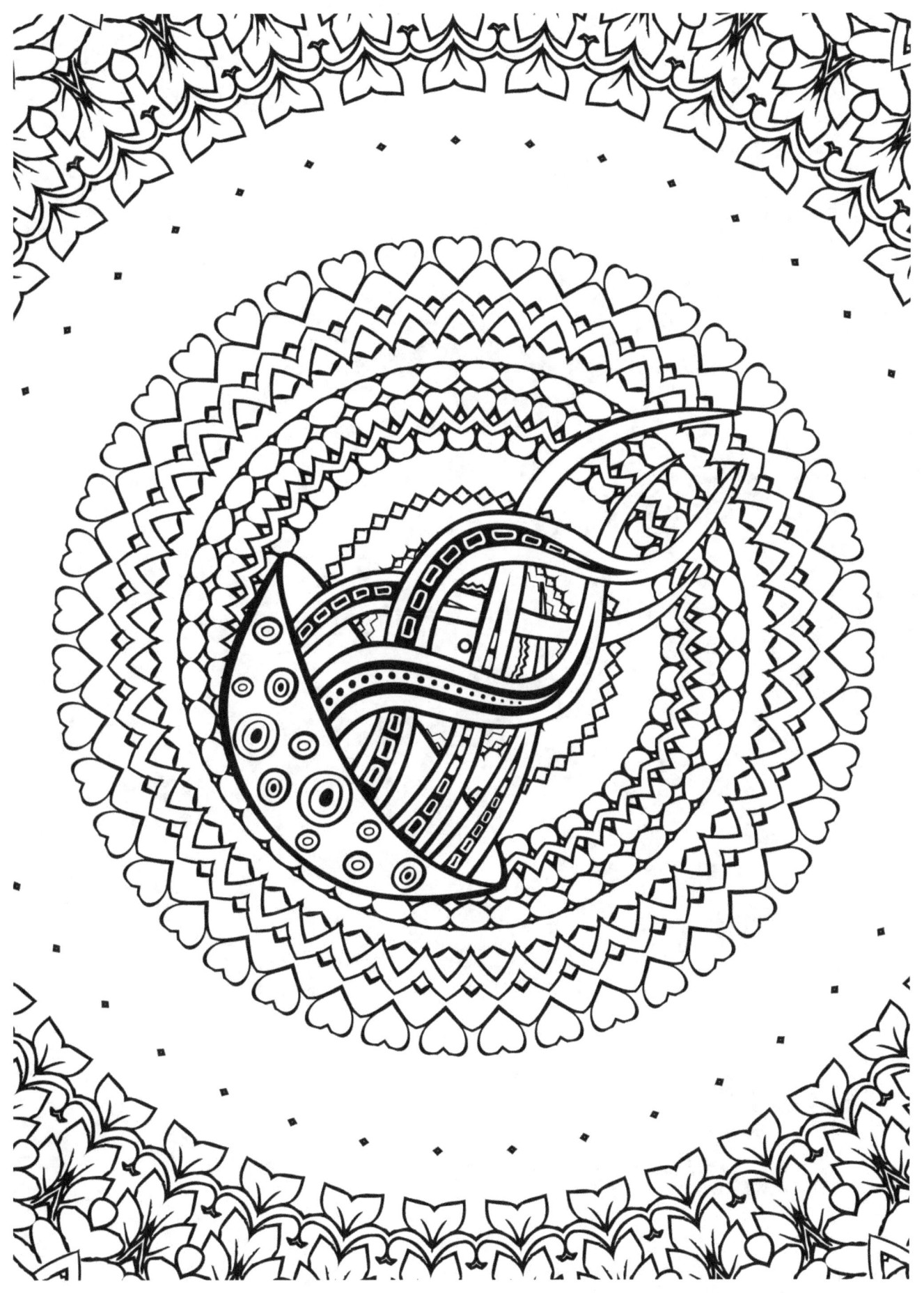

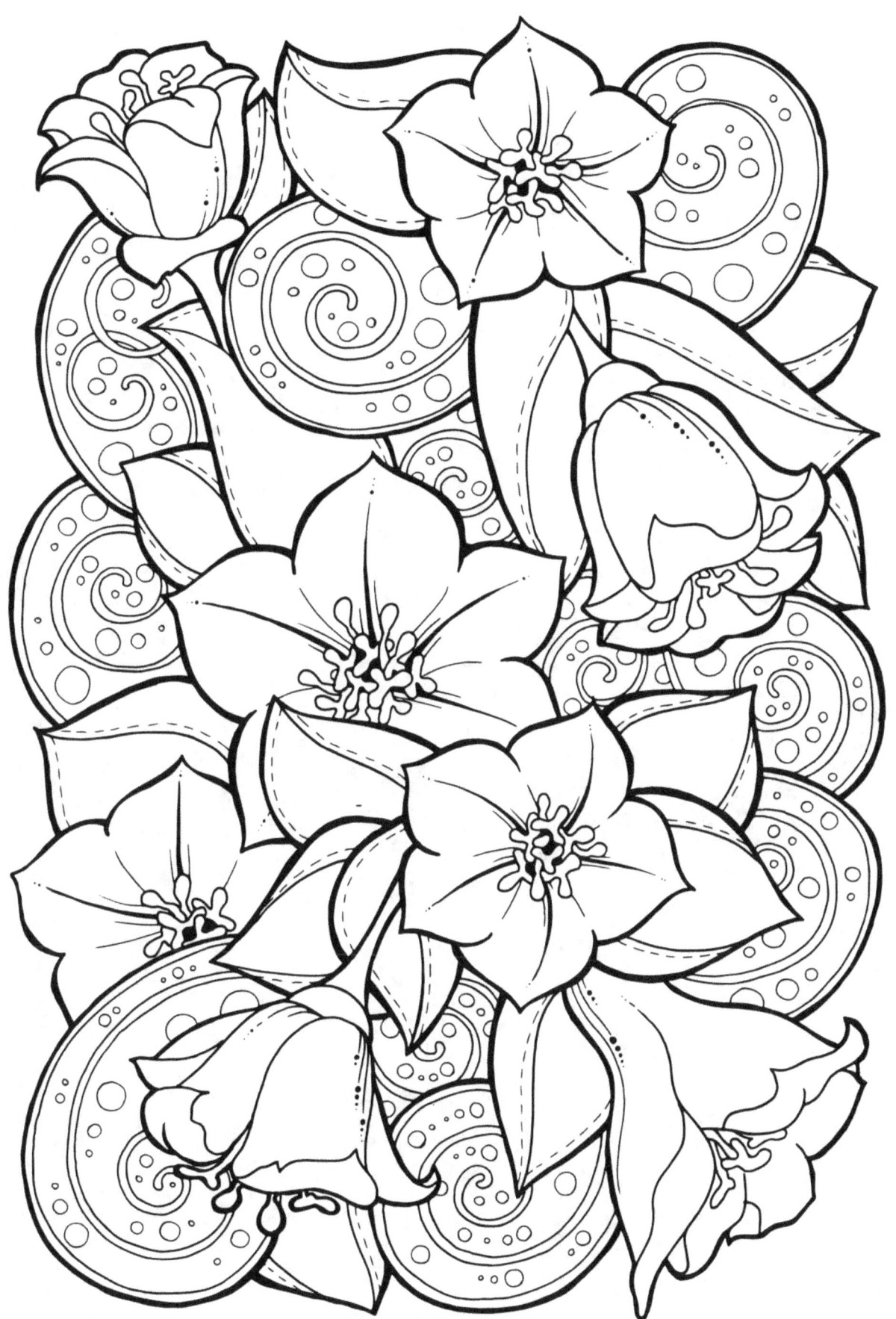

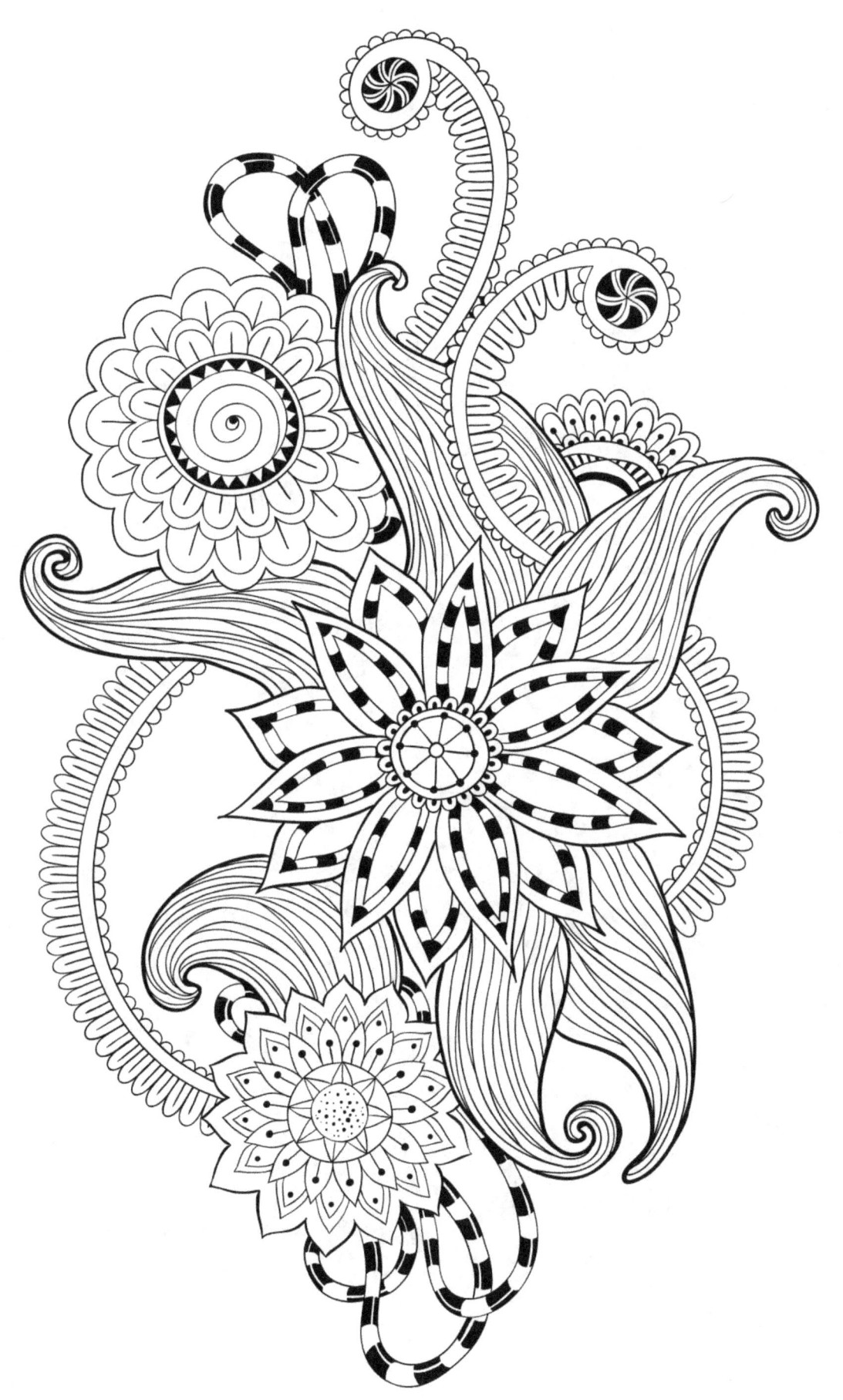

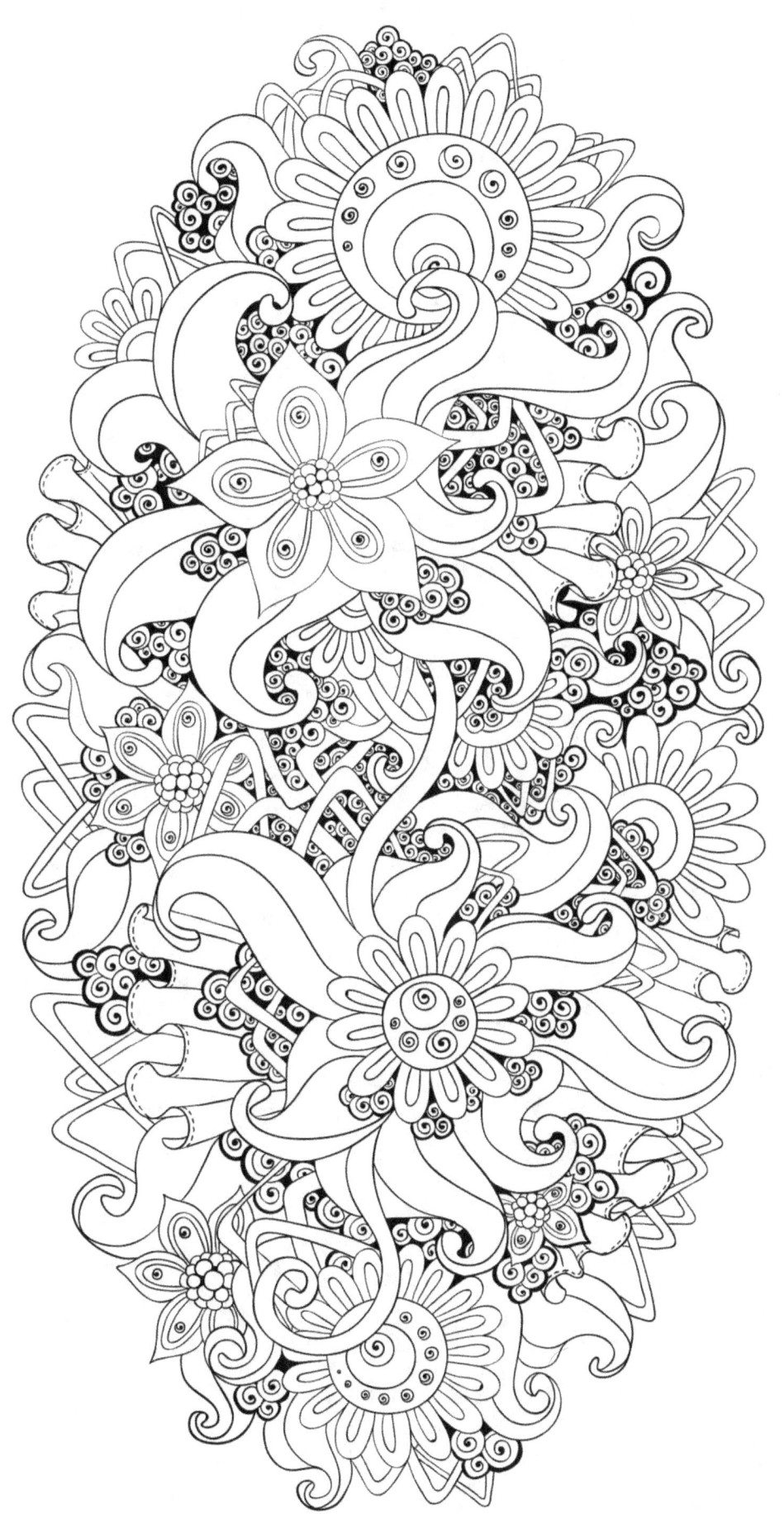

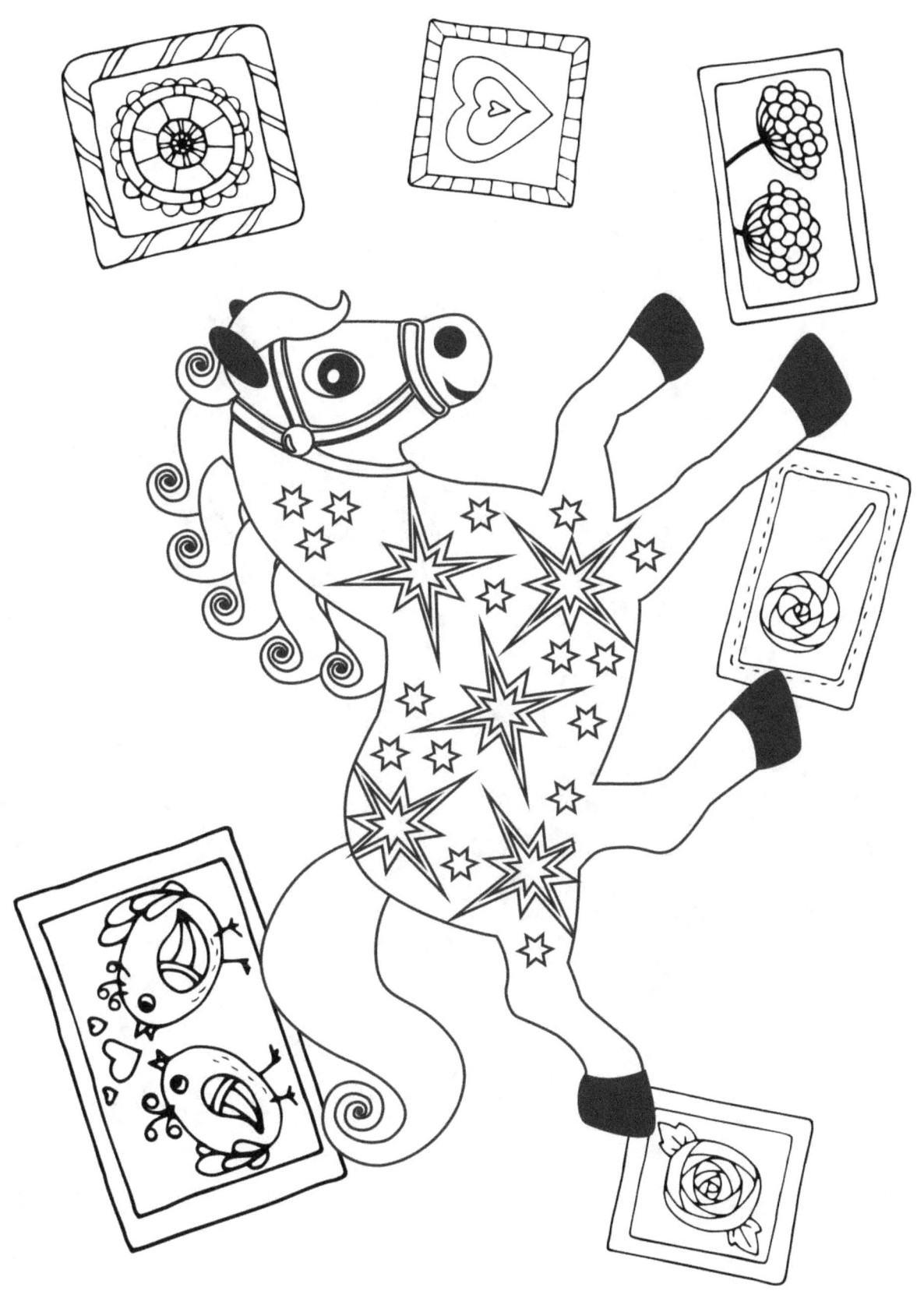